DALÍ
ON MODERN ART
The Cuckolds of Antiquated Modern Art

SALVADOR DALÍ

Translated by
HAAKON M. CHEVALIER

DOVER PUBLICATIONS, INC.
Mineola, New York

Bibliographical Note

This Dover edition, first published in 1996, contains only the English text and illustrations of the work originally published by The Dial Press, New York, 1957. The French text has been omitted, and all the calligraphic decorations in the French text that were not repeated in the English text have been redistributed in the frontmatter and backmatter.

Library of Congress Cataloging-in-Publication Data

Dalí, Salvador, 1904–1989.
 Dalí on modern art : the cuckolds of antiquated modern art / Salvador Dalí ; translated by Haakon M. Chevalier.
 p. cm.
 Originally published with English and French text: New York : Dial Press, 1957.
 Includes bibliographical references.
 ISBN 0-486-29220-7 (pbk.)
 1. Art, Modern—20th century. I. Title.
N6490.D234 1996
709'.04—dc20 96-13351
 CIP

Manufactured in the United States of America
Dover Publications, Inc., 31 East 2nd Street, Mineola, N.Y. 11501

Avidadollars

ANDRÉ BRETON

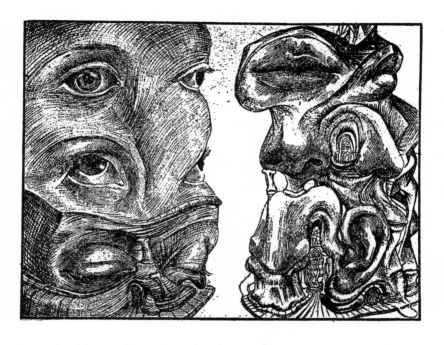

Architectonic project dated 1929, when I was defending the sublime genius of Gaudi in the face of the Protestant face of Le Corbusier.

Opening bars of Nietzsche's *Hymn to Friendship*

I EXPRESSLY WANT TO MAKE THIS communication in Paris, because France is the most intelligent country in the world, the most rational country in the world, whereas I, Salvador Dali, come from Spain, which is the most irrational country in the world, the most mystical country in the world.[1]

"Everyone knows that intelligence only leads us into the fog of scepticism, that its chief effect is to reduce us to factors having a gastronomical and supergelatinous, Proustian and gamey uncertainty. For which reasons it is well and necessary

[1] *In 1952, Dali wrote: "My country has an essential role to play in the great movement of 'nuclear mysticism' that is to mark our time. France will have a didactic role. She will probably draft the 'constitutive' act of nuclear mysticism by virtue of the prowess of her intelligence, but once again it will be Spain's mission to ennoble the whole by religious faith and beauty." (Editor's note).*

9

When I look at the starry sky, I find it small. Either I am growing, or else the universe is shrinking. Unless both are happening at the same time.

that Spaniards like Picasso and myself should come to Paris from time to time to dazzle you by putting a raw and bleeding piece of TRUTH before your eyes!''

It was with these words that I began my already excessively famous lecture at the Sorbonne on December 16, 1955, and it is exactly in the same manner that I intend to begin this lampoon, each new line of which is in the process of becoming classical, even if it be merely by the scratching of the paper on which I am writing.

The categorical heel-stamp of my pen, like a left leg, punctuates the haughtiest *zapateado*,[2] the *zapateado* of the jaws of my brain!

Olé!

[2] *The Spanish dancer marks the rhythm of his dance with sharp stamps of his heels and foot-beats in which Dali recognizes the hammerblows of his ideas.*

O LÉ! BECAUSE IT SO HAPPENS that the critics of the very antiquated modern art—who come from more or less central Europe, in other words from nowhere —are letting their most succulently Rabelaisian ambiguities and their most truculently Cornelian errors of situation in speculative cookery simmer in the Cartesian cassoulet.

The least magnificent ideological cuckolds[3]—with the exception of the Stalinian cuckolds—are two in number:

First: the old dadaist cuckold whose hair is turning white, who receives a diploma of honor or a gold medal for having tried to assassinate painting.

[3] *In Littré's Dictionary we find the following example given: "It was said that a married man whose wife was unchaste was called* cocu *(a cuckold), after a fine bird who is called a* cocu, *and by others a* couquon, *so named from its song; and for the reason that this fine bird goes and lays its eggs in the nests of other birds, being so stupid that it is incapable of making one for itself, so by antithesis and contrariety is he called a cuckold in whose nest another comes and lays an egg, that is to say begets offspring." Boucher. (Editor's note).*

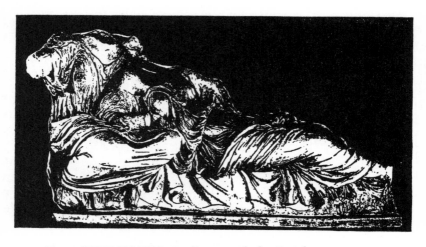

From **THE FATES.** *Pediment of the Parthenon.*
Since the well-nigh divine beginnings of the reclining body
its decline follows an inclined slope.

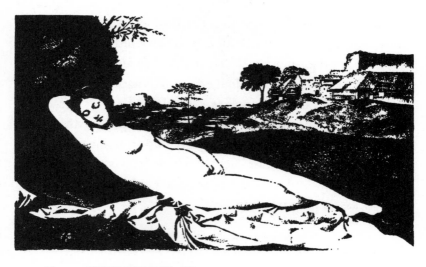

From **GIORGIONE.** *Venus.*
In the Renaissance it is still quite beautiful, though the
Dionysiac and Gaudinian side of vital tragedy is absent.

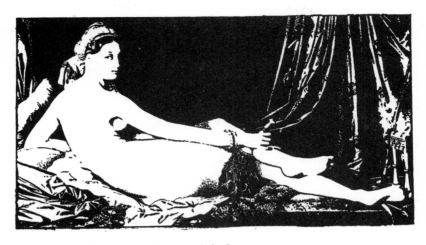

From INGRES. *The Odalisk.*

With Ingres it is still intact, but the French Revolution has passed, and bourgeois taste has appeared. Ingres resists.

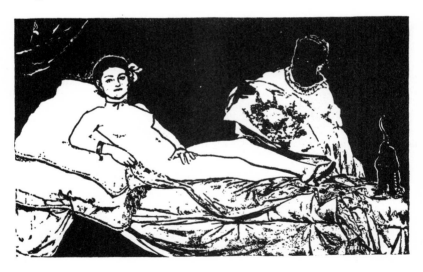

From MANET. *Olympia.*

Things are in a bad way . . .

With Matisse we shall witness the apotheosis of bourgeois taste.

*Ingres: the last painter who knew how to paint—was the integrity of his drawing.**

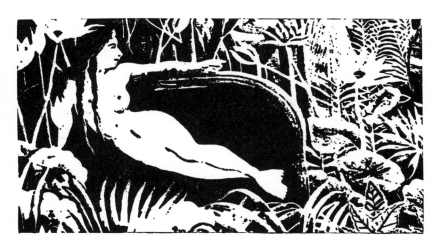

From ROUSSEAU. *The Dream* (Yadwigha).

After naturalism, only the naïve was lacking; to do full justice to it this artist isolates the detail of the nude.

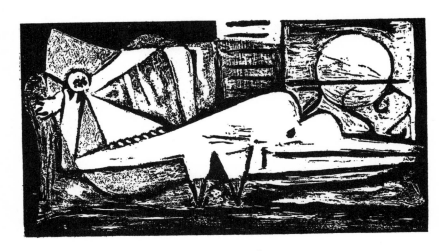

From PICASSO. *Reclining Nude.*

Grave in the extreme, cannot possibly get worse, pure bestiality.

Were it not for the extravagant titles that he gives to his canvases, Mr. Dali's painting would no longer be worth bothering with.

The critic of the *New York Times*

Second: the almost congenital cuckold, the dithyrambic critic of antiquated modern art, who straight away auto-recuckolds himself by dadaist cuckolding.

Since the dithyrambic critic has contracted marriage with antiquated modern art, the latter has been constantly unfaithful to him. I can mention at least four examples of this cuckolding:

1) He has been betrayed by the ugly.
2) He has been betrayed by the modern.
3) He has been betrayed by the technical.
4) He has been betrayed by the abstract.

The introduction of the ugly into modern art began with the romantic adolescent naïveté of Arthur Rimbaud, when he said, "Beauty seated herself on my knees and I grew weary of her." It is by virtue of these keywords that the dithyrambic critics—negativistic to the *n*-th degree, and hating classicism like any self-respecting sewer rat—discovered the biological agitations of the ugly and its unavowable attractions. They began to marvel at a new beauty, which they claimed to be "unconventional," and beside which classical beauty suddenly became synonymous with quaintness.

All ambiguities became possible, including that of savage objects, ugly as mortal sins (which is what they really are). In order to remain attuned to the dithyrambic critics, painters dedicated themselves to the ugly. The more of it they turned out, the more modern they were. Picasso, who is afraid of everything, went in for the ugly because he was afraid of Bouguereau.[4] But he, unlike the others, went in for it on purpose, thus cuckolding those dithyrambic critics who claimed

[4] *Bouguereau, Adolphe-William, to quote the Twentieth-Century Larousse. Born in 1825, died in 1905. Covered with diplomas and gold medals, he is regarded as the general of conventionalists. But he is a discredited general who*

The actualizing of African, Lapp, Lett, Breton, Gallic, Majorcan or Cretan arts is but an effect of modern cretinization. It's all Chinese, and God knows how little I like Chinese art.

to be rediscovering true beauty. Only as Picasso is an anarchist, after having knifed Bouguereau half to death, he was going to give the *puntilla*,[5] and finish off modern art at one blow by out-uglying, alone, in a single day, the ugly that all the others combined could turn out in several years.

For the great Pablo, the angelic Raphaël, the divine Marquis de Sade and I—the rhinocerontesque Salvador Dali—actually have the same idea as to what an archangelically beautiful being may represent. This idea, in fact, in no way differs from the one instinctively possessed by any crowd in the street—bearer of the heritage of Graeco-Roman civilization—when it turns round, petrified with admiration at the passage of a body —let us call a spade a spade—of a Pythagorean body.

At the algid[6] moment of his greatest frenzy of ugliness, I sent Picasso the following telegram from New York:

> Pablo thanks! Your last ignominious paintings have killed modern art. But for you, with the taste and moderation that are the very virtues of French prudence, we should have had painting that was more and more ugly, for at least one hundred years, before reaching your sublime adefesios esperentos.[7] You, with all the violence of your Iberian anarchism, have achieved the limits and the

still inspires fear. One day Picasso asked a friend of his how he liked his latest work, a collage *made of pieces of newspaper. When his friend remained speechless the master, beside himself, found the telling formulation. "It may not be sublime," he said, "but at least it's nothing like Bouguereau." (Editor's note).*

[5] *Next to the dance, bullfighting is Dali's favorite source of images. He is certainly a Spaniard. (Editor's note).*

[6] *The* algid *period of cholera is the period during which the patient suffers from chill. (Editor's note).*

[7] *The phrase is Picasso's own. Literally it means "persons who are ugly and ridiculous as scarecrows." But it is probable that Picasso combines this idea with a certain phantasmagoric immateriality. (Editor's note).*

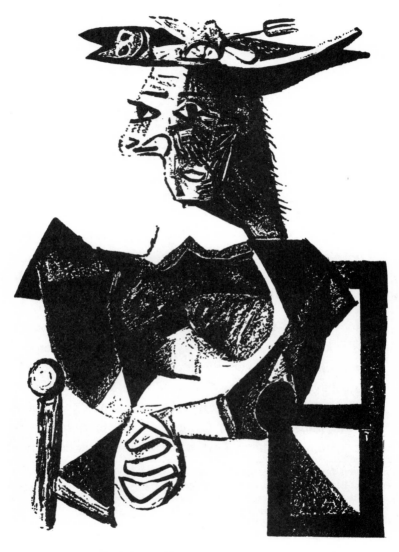

From PICASSO. *The Woman with the Fish-hat.*
It's not that beautiful.

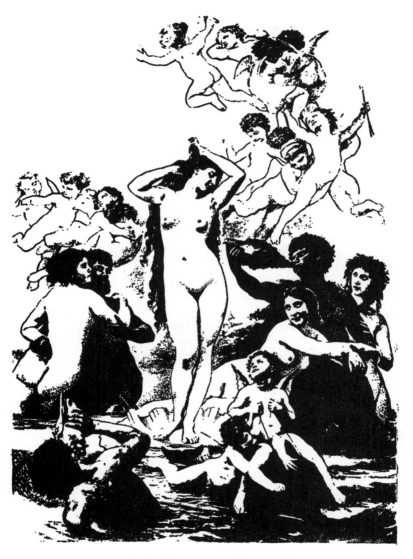

From BOUGUEREAU. *Birth of Venus.*
It's not that frightful.

Picasso wanted to be a communist. He has nevertheless remained the king of us all. In ten years it will be said that as a painter Picasso was not that good, and Bouguereau not that bad. One day Picasso said to me, "In any case, we are as good and as useful as those buffoons whom the kings of Spain used to keep in their courts and whose opinions they respected." To which I replied, "We are today the only beings possessed of a royal will."

final consequences of the abominable in a mere few weeks. And this you have done, as Nietzsche would have wished, by marking it with the seal of your own blood. Now all that remains for us is to turn our eyes once more to Raphael. God preserve you!

<div align="right">Salvador Dali.</div>

All this ended up in the false Cartesian and scatological explosion of Dubuffet. But the dithyrambic critics of antiquated modern art remained and will long continue to remain prostatic and joyous with the ugly seated on their knees. They will not grow weary of it.

Buffet, more quaint than Puvis de Chavannes, is scarcely even ugly.

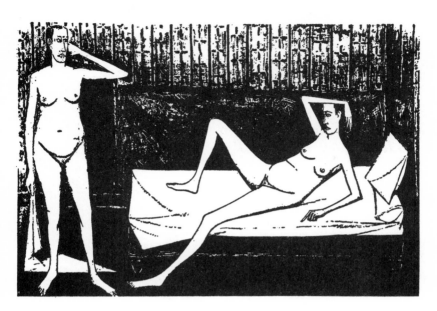

From B. BUFFET. *Two Female Nudes.*
It won't get any worse, for Picasso has killed all this.

From PUVIS DE CHAVANNES. *The Poor Fisherman.*
Buffet would paint this two hundred years hence if he had the talent of Puvis de Chavannes.

Dali has had the courage, at the height of the "modern" period, to strive to emulate Meissonnier and he has nevertheless succeeded in painting like Dali!

THE CRITICS OF ANTIQUATED MOD-
ern art have especially been led astray and cuckolded by the
"modern" itself. Nothing, in fact, has ever aged more rapidly
and more poorly than all that they at one moment qualified as
"modern."

When I was barely twenty-one years old, I happened to be
having lunch one day at my friend Roussy de Sales' in the com-
pany of the masochistic and Protestant architect Le Corbusier
who, as everyone knows, is the inventor of the architecture of
self-punishment. Le Corbusier asked me if I had any ideas on
the future of his art. Yes, I had. I have ideas on everything, as
a matter of fact. I answered him that architecture would become
"soft and hairy" and I categorically affirmed that the last great
genius of architecture was called Gaudi whose name, in Catalan,
means "enjoy," just as Dali means "desire." I explained to him
that enjoyment and desire are characteristic of Catholicism and

With his paranoiac-critical method Dali has contributed to surrealism a first-rate weapon.

ANDRÉ BRETON

of the Mediterranean Gothic, reinvented and brought to their paroxysm by Gaudi. In listening to me, Le Corbusier had the expression of one swallowing gall.

Later, the very "modern" *Cahiers d'Art* were to launch an attack on Gaudi, of a perfectly modern mediocrity. To defend him I wrote some masterly pages, worthy of an anthology, on *Modern Style* and the Paris subway entrances. I cannot resist the desire to reproduce these in their entirety, as they appeared in number 3-4 of the *Minotaure.**

Colossal, ravishing incomprehension of the phenomenon

The readily literary utilization of the "1900" style tends to become frightfully continuous. To justify it a pleasant, much-quoted formula is used, mildly nostalgic, mildly comical, capable of provoking a "kind of smile" that is peculiarly repulsive: I mean a discreet and witty "Laugh, Clown, laugh," based on the most lamentable mechanisms of "sentimental perspective" by virtue of which it is possible, with a very exaggerated distance, to judge by contrast a relatively close period. In this manner anachronism, in other words the "delirious concrete" (sole vital constant) is presented to us (in consideration of the intellectualist aestheticism attributed to us) as the essence of the "ephemeral out of its accustomed surroundings" (ridiculous—melancholy). It can be seen that what is involved is an "attitude" based on the smallest, the least arrogant "superiority complex," accompanied by a coefficient of "sordid-critical" humor that makes everyone happy and enables

* *This article was called "As of the Terrifying and Edible Beauty of Modern Style Architecture."* (Editor's Note.)

Painter, if you want to ensure for yourself a prominent place in Society you must, in the first flush of your youth, give it a violent kick in the right leg.

anyone who wants to display concern with preserved artistic-retrospective realities to appraise the unheard-of phenomenon with the prescribed and decent facial contractions. These facial contractions, treacherous reflexes of "repression-defense," will have the effect of inducing an alternation of benevolent and understanding smiles—tinged, to be sure, with the indispensable well-known tear (corresponding to "conventional memories," simulated ones)—and bursts of laughter, frank, explosive, irresistible though devoid of vulgarity, every time one of those violent, hallucinating "anachronisms" appears, whether in connection with one of those tragic and grandiose edible sado-masochistic costumes or, even more paradoxically, with one of those terrifying and sublime Modern Style ornamental architectures.

I believe I was the first, in 1929 and at the beginning of *La Femme visible,* to consider the delirious Modern Style architecture as the most original and the most extraordinary phenomenon in the history of art, and I did so without a shadow of humor.

I here emphasize the essentially extra-plastic character of Modern Style. To my mind, any use of the latter for properly "plastic" or pictorial ends could not fail to imply the most flagrant betrayal of the irrationalist and essentially "literary" aspirations of these movements. The "replacement" (a question of fatigue) of the "right-angle" and "golden section" formula by the convulsive-undulating formula can in the long run only give rise to an aestheticism as melancholy as the preceding one—momentarily less boring because of the change, and that is all. The best subscribe to this formula: a curved line appears today to become once more the shortest distance between two points,

*Since my first childhood I have had a
vicious turn of mind that makes me con-
sider myself different from the common
run of mortals. This still persists, and I
have never failed to thrive by it.*

and the most vertiginous—but all this is but "the ultimate wretchedness of plasticism," an antidecorative decorativism, contrary to the psychic decorativism of Modern Style.

Apparition of the Cannibal Imperialism
of Modern Style

The "manifest" causes that have produced Modern Style still appear to us too confused, too contradictory and too vast to make it possible to determine them at the present time. The same could be said for its "latent" causes, although the intelligent reader may be led to deduce from what will be said that the movement that concerns us was mainly aimed at awakening a kind of great "original hunger."

Like the determination of its "phenomenological" causes, any attempt at an historical elucidation concerning it would encounter the greatest difficulties, especially by reason of that contradictory and rare collective sentiment of ferocious individualism that characterizes its genesis. Let us therefore limit ourselves today to noting the "fact" of the brusque apparition, of the violent irruption of Modern Style, testifying to an unprecedented revolution in the "sense of originality." Modern Style, in fact, appears as a leap, with all the most cruel traumatisms for art that such a leap may entail.

It is in architecture that we shall have an opportunity of marveling at the deep shattering, in its most consubstantially functionalist essence, of every "element" of the past, even the most congenital, the most hereditary. With Modern Style the architectural elements of the past, aside from the fact that they will be subjected to the frequent, to the total convulsive-formal

Painter, do not concern yourself with being modern. It is the only thing, unfortunately, no matter what you do, that you cannot avoid being.

grinding that will give birth to a new stylization, will be called upon to live again, to subsist currently in the true aspect of their origins, so that in combining with one another, in melting into one another (despite their most intellectually irreconcilable and irreducible antagonisms) they will reach the highest degree of aesthetic depreciation, will manifest in their relations that frightful impurity that has no other equivalent or equal than the immaculate purity of oniric intertwinings.

In a Modern Style building, Gothic becomes metamorphosed into Hellenic, into Far-Eastern and, should it occur to one—by a certain involuntary whim—into Renaissance which in turn may become pure, dynamic-asymmetrical (!) Modern Style, all in the "feeble" time and space of a single window, that is to say in that time and that space, little-known and probably vertiginous, which as we have just insinuated, are none other than those of dreams. Everything that was the most naturally utilitarian and functional in the known architectures of the past suddenly ceases, in Modern Style, to serve any purpose whatever or, which is hardly calculated to win over pragmatist intellectualism, serves only for the "functioning of desires," these being, moreover, of the most turbid, disqualified and unavowable kind. Grandiose columns and medium columns, inclined, incapable of holding themselves up, like the tired necks of heavy hydrocephalic heads, emerge for the first time in the world of hard undulations of water sculptured with a photographic scrupulousness of instantaneity until then unknown. They rise in waves from the polychrome reliefs, whose immaterial ornamentation congeals the convulsive transitions of the feeble materializations of the most fugitive metamorphoses of smoke, as well as aquatic

I sing your longing for limit eternal!
FEDERICO GARCIA LORCA

vegetations and the hair of those new women, even more "appetizing" than the slight thirst caused by the imaginative temperature of the life of the floral ecstasies into which they vanish. These columns of feverish flesh (37.5°C.) are destined to support nothing more than the famous dragon-fly with an abdomen soft and heavy as the block of massive lead out of which it has been carved in a subtle and ethereal fashion, a block of lead such (by its ridiculous excess of weight which nevertheless introduces the necessary idea of gravity) as to accentuate, aggravate and complicate in a perverse way the sublime sentiment of infinite and glacial sterility, to render more comprehensible and more lamentable the irrational dynamism of the column, which as a result of all these circumstances of delicate ambivalence cannot fail to appear to us as the true "masochistic column" having solely the function of "letting itself be devoured by desire," like the actual first soft column built and cut out of that real desired meat toward which Napoleon, as we know, is always moving at the head of all real and true imperialisms which, as we are in the habit of repeating, are nothing but the immense "cannibalisms of history" often represented by the concrete, grilled and tasty lamb-chop that the wonderful philosophy of dialectical materialism, like a new William Tell, has placed on the very head of politics.

Thus in my view it is precisely (I cannot emphasize this point too strongly) the wholly ideal Modern Style architecture that incarnates the most tangible and delirious aspiration of hyper-materialism. An illustration of this apparent paradox will be found in a current comparison, made disparagingly it is true, yet so lucid, which consists in assimilating a Modern Style house

to a cake, to a pastry-cook's exhibitionistic and ornamental tart. I repeat that this is a lucid and intelligent comparison, not only because it emphasizes the violent materialist-prosaicism of the immediate, urgent needs on which ideal desires are based, but also because by this very fact and in reality, the nutritive and edible character of this kind of house is thus alluded to without any euphemism, these houses being nothing other than the first edible houses, the first and only erotizable buildings, whose existence verifies that urgent "function," so necessary to the amorous imagination: to be able quite really to eat the object of desire.

Modern Style, Phenomenal Architecture
General Characteristics of the Phenomenon

Deep depreciation of intellectual systems.—Highly accentuated depression of the reasoning activity, to a degree bordering on mental debility.—Positive lyrical imbecility.—Total aesthetic unconsciousness.—No lyrical-religious coaction; on the other hand: release, freedom, development of the unconscious mechanisms.—Ornamental automatism.—Stereotype.—Neologisms.—Great childhood neurosis, refuge in an ideal world, hatred of reality, etc.—Delusion of grandeur, perverse megalomania, "objective megalomania."—Need and feeling for the fanciful and hyperaesthetic originality.—Absolute shamelessness of pride, frenzied exhibitionism of "caprice" and imperialist "fantasy."—No notion of restraint.—Realization of solidified desires.—Majestic blossoming with erotic, irrational, unconscious tendencies.

Psychopathological Parallel

Invention of "hysterical sculpture."—Continuous erotic ecstasy.—Contractions and attitudes without antecedents in the history of statuary (reference is to the women discovered and known after Charcot and the school of la Salpêtrière).—Confusion and ornamental exacerbation in relation to pathological communications; dementia praecox.—Close affinities with the dream-world; reveries, waking fantasies.—Presence of characteristic oniric elements: condensation; displacement, etc.—Development of the anal sadistic complex.—Flagrant ornamental coprophagia.—Very slow, exhausting onanism, accompanied by an enormous sense of guilt.

Extra-Plastic Concrete Aspirations

The sculpture of everything that is extra-sculptural: water, smoke, iridescences of pre-tuberculosis and nocturnal pollution, woman-flower-skin-peyotl-jewels—cloud-flame-butterfly-mirror. Guadi built a house patterned on the forms of the sea, "representing waves on a stormy day." Another is built of the still waters of a lake. I am not indulging in idle metaphors, fairytales, etc., these houses actually exist (Paseo de Gracia in Barcelona). I am speaking of real buildings, a real sculpturing of reflections of twilight clouds in water, made possible by recourse to an immense and insane multicolored and gleaming mosaic of pointillist iridescences from which emerge forms of spread water, forms of water puckered by the wind, all these forms of water built in an asymmetrical and dynamic-instantaneous succession of reliefs, broken, syncopated, en-

twined, fused by the "naturalist-stylized" water lilies and nympheals being materialized in impure and annihilating eccentric convergences by thick protuberances of fear, spurting from the incredible façade, contorted both by all the demential suffering and by all the latent and infinitely sweet calm that is equaled only by that of the horrifying apotheosic and ripe furuncle ready to be eaten with a spoon—with the bleeding, fat, soft spoon of gamey meat that is approaching.

The point was thus to build a habitable structure (one which, moreover, as I claim, should be edible) with the reflections of twilight clouds on the waters of a lake, the work having in addition to embody a maximum of naturalistic exactness and optical illusion. I proclaim that this is a gigantic improvement on the mere Rimbaldian submersion of the drawing-room at the bottom of a lake.

Return to Beauty

Erotic desire is the ruin of intellectualist aesthetics. Where the Venus of logic vanishes, the Venus of "bad taste," the "Venus in furs" appears beneath the banner of the only beauty, that of real vital and materialist agitations.—Beauty is but the epitome of consciousness of our perversions.—Breton has said, "Beauty shall be convulsive or nothing." The new surrealist age of the "cannibalism of objects" likewise justifies this conclusion: "Beauty shall be edible or nothing."

Salvador DALI

TODAY, TWENTY YEARS AFTER THIS
article in *le Minotaure*, I have won the battle for Gaudi, for my
friends Alfred Barr,[1] director of the Museum of Modern Art in
New York, and Sweeney, of the Museum of Non-Objective Art,
have recognized his genius by writing one of the most important
books about him. And the admiration that Le Corbusier himself
feels for Gaudi[2] he has transcended in his own architecture,
which is wholly to his honor.

But it is easier to approximate the genius of Gaudi than

[1] *Alfred Barr was one of Dali's earliest friends. It was he who persuaded
him to come to the United States. In his* Secret Life *Dali says of him: "His jerky
gestures reminded one of those of pecking birds. And what he was in fact doing
was to peck and scratch about among contemporary values, judiciously selecting
the sound grain and separating it from the chaff." (Editor's note).*

[2] *In 1935, during the Barcelona uprising, Gaudi's body was exhumed and
dragged through the streets by urchins. The friend who described the scene to
Dali added that Gaudi looked very well embalmed and preserved, but seemed at
the moment to be a bit under the weather. (Editor's note).*

*The least that one can ask of a piece of
sculpture is that it should not move.*

that of Raphael, the first being a genius surrounded by the thunder of cataclysms and the other a genius bathed in celestial silence. What is now to be won is the battle for Raphael, the most decisive and the hardest of all. It is only in the just appraisal of Raphael that the true superior spirits of our epoch can be recognized, since Raphael is the most anti-academic, the most tenderly living and the most futuristic of all the aesthetic archetypes of all times.

I ask of my friends Le Corbusier, Barr and Sweeney, and especially Malraux, that they pause a moment to examine how terribly one of those glued, yellow, anecdotic, literary and sentimental papers of the cubist period has aged, both physically and morally! Let them compare it to the little Saint George by Raphael,[3] which has remained fresh as a rose! But I am not sanguine of the result, for these four are still too much on the side of the cataclysm!

But, whether solicited by cataclysm or heaven, our moderns could not endure the least vestiges of ornamentation in their "dwelling machines" and they have been invaded by abstract academicism which is only very mediocre pseudo-decorative art.

Our moderns, whose hair bristles with horror at the idea of a matter that is not aseptic and prefabricated, have not had to wait till the end of their lives to witness the apotheosis of the most naïve folklore, the resurrection of all plagiarisms, of all archeologisms of all times, on the sole condition that these be soiled and falling apart. Every self-respecting modern painting, piece of pottery or carpet must seem to have come from an excavation and simulate the accidents of patina and truculent decrepitude. And this to a point that one would not have tol-

[3] *In the Mellon collection in Washington. (Editor's note).*

Something comes to an end with the death of that painter of seaweed just barely suitable for helping the bourgeois digestion—I mean Matisse, the painter of the revolution of 1789.

erated in the time of the lamented "Michelangelo buffets," when one contented oneself with imitating modest worm-holes.

And after all, what is more cuckolded, more betrayed, more afflicted with cracks than this modern art with its mania for the sterilized cleanliness of functional forms and aseptic surfaces, whereas one would think it was plague-ridden and had been found, by an irony of destiny, as they say, in those garbage cans where the Italian Burri goes rummaging for blood-stained rags. Even though eternally and blithely cuckolded, Burri none the less suspends above his head those pieces of refuse that have the form of the most depressing of all "mobiles" like those that a "first prize-winner" in modern—modern—sculpture makes to order for him.

Advocates of the ultra-new, snubbed by the parvenus of the pseudo old-old, the dithyrambic critics have been led astray by technique; with Impressionism the decadence of pictorial art became . . . impressive.

Paul Cézanne—one of the most marvelously reactionary painters of all time—was also one of the most "imperialistic," since he wanted to redo Poussin "from nature," hence according to the new conception of the discontinuity of matter, the great truth of the Dionysiac divisionism of Impressionism. It is unfortunate that his Apollonian impulse[4] was betrayed by his fatal clumsiness. His awkwardness can be compared only to the delirious virtuosity of Velasquez. It should have been Velasquez who, like Bonaparte, poured the anarchy of orgiac painting into the

[4] *It will be recalled that in Nietzsche's philosophy "Apollonian" designates one who has the faculty of creating real images. Whereas in the same philosophy, "Dionysiac" is used of the state in which man is conscious of himself as capable of representation or intelligence. (Editor's note).*

Even as Voltaire with the Heavenly Father,
Braque and I bow to each other, but we do
not speak!

Caesarian empire of forms, adding that notion of discontinuous nature that Poussin lacked.

But, however touching it may be, never did Cézanne succeed in painting a single round apple capable of holding—monarchically—the five regular bodies[5] within its absolute volume.

The dithyrambic critics, completely in line with the mediocrity of Cezannian paintings, were only able to set up as categorical imperatives the catastrophic deficiencies, clumsinesses and awkwardnesses of the master. Before this total rout of means of expression it was believed that a step had been taken toward the liberation of pictorial technique. Every failure was baptized economy, intensity, plasticity—and when that horrible word, "plasticity," is uttered, it means that the worms are already at work!

In short, deceived but gay as usual, the dithyrambic critics, instead of finding themselves in possession of the noble basket of intact and divine apples—the symbol of a new Cezannian golden age—were simply left alone with a basket filled with their own shit.[6] And since, even to weave a simple basket with dignity a certain technique remains indispensable, they had succeeded in fabricating only a kind of basket utterly unworthy of the name. Never can Michel de Montaigne's expression, "to shit[7] in one's basket and then put it on one's head," be more

[5] *That is to say: the cube, the tetrahedron, the dodecahedron, the hexahedron and the octahedron. (Editor's note).*

[6] *"In ancient Rome no difficulty was made over speaking of shit. Horace, the delicate Horace, and all the poets of the century of Augustus, speak of it in a hundred places in their works." (Comte de Caylus).*

[7] *Another example of the use of this rare word: "Here lies a king, wonderful to relate, who died, as God wills, by the blow of a brush-hook and an old woman as he was shitting into a chest." (d'Aubigné).*

The two geniuses of creative forms (dynamism of the discontinuity of matter instantaneously congealed) are the Italian Boccioni and the Catalan Gaudi, who have made of Milan and Barcelona the capitals of the industrial revolution.

wisely applied than to those dithyrambic critics of the new technique of modern painters.

Barely had they been successively betrayed by the "ugly" and the "modern," then by "technique," than our dithyrambic critics were once more, without being given any respite, cuckolded then and there by "abstract art." But this time the cuckolding was colossal, totalitarian, imperial, I would almost say cosmic both in its spiritual aspect (so thoroughly blasted that nothing worse could happen to it) and in its temporal aspect, for it is no longer a mystery that those who had put their faith in it are in the process of losing all their money, a sure sign of bankruptcy.

The deceit began with Picasso whose Andalusian blood bore in its current pieces of that monument of iconoclasm which is the Alhambra of Granada. Then cubism went about smashing matter into smithereens, still using the materials of the "neo-Platonic mason" that Cézanne made use of to keep his houses standing up. To this cubism was to add a little cement from Huerta del Ebro in Aragon, for the earth of Aragon is the most ferociously realistic and concrete in the world.

It is not difficult, on looking back, to see that the materials used by Cézanne, plus those materials furnished to cubism by the earth of Aragon, were Catholic *par excellence,* and that it was only with them that it was going to be possible to paint reality. A certain Arab coquetry would, moreover, reveal itself perfectly adequate to fragment the too dry and too peeled Hispano-Moorish form, just as the impressionists had decomposed light with the moist subtlety that falls from the skies of Delft. How, too, could one fail to recognize this subtlety in

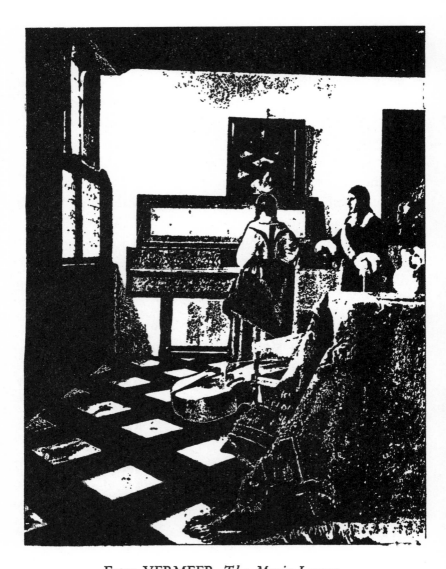

From VERMEER. *The Music Lesson.*
It is more beautiful than what has been said about it and more beautiful than anything we believe about it.

From MONDRIAN. *Composition.*
Piet "Niet."

Juan Gris, you are the categorical execu-tioner of the Discourse on the Cubic Form *by Juan de Herrera, the architect of Philip II of Spain. The Escurial, like yourself, is realism and mysticism made architecture. Juan Gris, I like you very much! With Seurat, you are the most classic of the moderns.*

the maternal and Atlantic reminiscences and regrets of Velasquez, whose mother was Portuguese, which explains the miracle of the painting of the greatest of all artists: the virile member of Castille forever wet with an ejaculation that only the granitic veins of Spain could conduct by mysterious channels to the painter's pupil.

Cubism thus was and remains merely the most heroic effort to preserve the object (genius and object to the grave) at the moment when a full consciousness of the new discontinuity of matter was being acquired. In point of fact, the concern continued to be with objects, ever with objects, concrete and anecdotic objects that came to bear the labels of their own sentimental anecdote. The guitars are of cement, their angles cut hands and faces with the objective grinding of their structures. All this objectivity carried to its paroxysm is not glaringly obvious to the aestheticians who regard it as a stage in the direction of the abstract rather than a revolt of the object.

There is nothing abnormal in this, and Picasso once confessed to me privately that none of the panegyrists of his gray cubism had ever been able to see what his paintings represented. Hence from these monstrous academicisms were born all the neo-plasticisms and in particular that degrading example of mental debility that was pompously called "abstraction-creation."

And so one was to hear the Piet, Piet, Piet of the new modern academicians. This Piet Mondrian, however, had a soft spot for Dali. He used to say that no one in the world was capable as I was of placing a small stone that projects its shadow in the space of a painting. I in turn have a soft spot for Mondrian, for as I adore Vermeer I find in Mondrian's order the

chamber-maid's cleanliness of Vermeer and even his retinian instantaneity of blues and yellows. I nevertheless hasten to say that Vermeer is almost everything and Mondrian almost nothing!

Completely idiotic critics have for several years used the name of Piet Mondrian as though he represented the *summum* of all spiritual activity. They quote him in every connection. Piet for architecture, Piet for poetry, Piet for mysticism, Piet for philosophy, Piet's whites, Piet's yellows, Piet, Piet, Piet. .Piet, Piet, Piet, Peep, Pity, Piet. Well, I Salvador, will tell you this, that Piet with one "i" less would have been nothing but a *pet,* which is the French word for fart.[8]

[8] *"Suddenly Epistemon began to breathe, then to open his eyes, then to yawn, then sneeze, then let a large household fart." (Rabelais, II, 30).*

Of all the pupils of Gustave Moreau, the best will always be the one who taught them.

A<small>N ARAGONESE</small> *jota* <small>HAS THIS</small>
strident refrain, a visceral, Iberian and irrational cry:

"I love you as one loves one's mother
as one loves money!"

What I like best in all the philosophical writings of
Auguste Comte is the precise moment where, before founding
his new positivist religion, he places the bankers, whom he
regards as of capital importance, at the summit of his hierarchy.
Perhaps this is the Phoenician side of my Ampurdan blood, but
I have always been dazzled by gold in whatever form it appears.
Having learned in my adolescence that Miguel de Cervantes,
after having written his immortal *Don Quixote* for the greater
glory of Spain, died in wretched poverty, that Christopher
Columbus, after having discovered the New World, had also

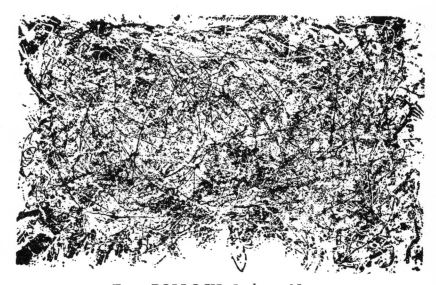

From POLLOCK. *Jackson, No. 1.*
The same fish-soup as Monticelli, but far less tasty, merely the
indigestion that goes with it.

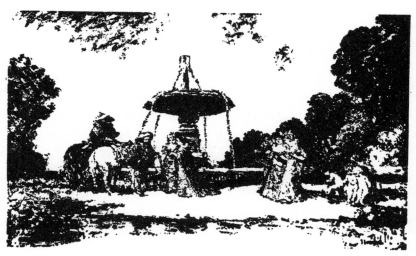

From MONTICELLI. *The Fountain.*
Fish-soup for fish-soup's sake.

died under the same conditions, and in prison to boot, already in my adolescence, as I say, my prudence strongly counseled me two things:

1) to have my prison experience as early as possible. And this was done.

2) to become to the greatest extent possible a bit of a multimillionaire. And this, too, is done.

The simplest way of refusing any concession to gold is to have some oneself. With gold it becomes quite unnecessary to "engage oneself." A hero does not engage himself anywhere! He is the very opposite of a servant. One really must have teeth covered with Sartre not to dare to speak like this! So let us be prudent, as Saint-Granier[1] recommends, if we want to permit ourselves to be Nietzschean. All the concrete values of modern painting will remain eternally translatable on the material level into that thing that I personally have always loved: *money!*[2]

In compensation, the pure critics who have consistently despised money and been afraid to dirty their hands by touching it may rest assured: the abstract values that they defend in modern paintings will inevitably be converted into absolutely clean,

[1] *A Paris radio commentator who broadcasts a daily one-minute program in which he deals in a folksy, common-sense way with everyday problems. (Translator's note).*

[2] *As everybody knows, André Breton baptized Dali "Avida Dollars." Dali claims that this anagram was his talisman which made "the rain of dollars fluid, gentle and monotonous." He has promised himself some day to tell the whole truth about this blessed profligacy of Danaë. It will form a chapter of a new book to be entitled "The Life of Salvador Dali Considered as a Masterpiece." (Editor's note).*

Without the slightest hesitation, without a doubt, the worst painter in the world is called Turner.

wholly inoffensive and immaterial money. It will be purely abstract money.

END

S. S. AMERICA
EN ROUTE TO LE HAVRE. APRIL 1956.

EPILOGUE

Children have never particularly interested me, but the thing that has interested me even less is the drawings of children.

I

N THE WHOLE MODERN REVOLUTION one single idea has not aged and remains so living that it will be the foundation of the new classicism that is imminently awaited. None of the dithyrambic critics of antiquated modern art has yet noticed it. It involves nothing less than Paul Cézanne's famous *from nature*.[1]

The Discontinuity of Matter

The most transcendent discovery of our epoch is that of nuclear physics regarding the constitution of matter. Matter is discontinuous and any valid venture in modern painting can and must proceed only from a single idea, as concrete as it is significant: *the discontinuity of matter*.

This discontinuity is announced for the first time in the history of art by Vermeer's corpuscular touches and Velasquez's

[1] *Nature is the name that the painter gives to physics. (Editor's note).*

*Miro, who basely tried to murder painting, had the courage to let himself be eaten by folklore.**

He is nevertheless the best in his field, for the good reason that he is a Catalan! (S.D.)

brush-strokes in the air. Likewise, it is impressionism which for the first time invented the division of light. Seurat's chromosomatic confetti are the notarized act of the discontinuity of matter. The sadistic collision of complementaries in the perimeter—broken up by the Brownian movement—of Cézanne's apples, is but the physical manifestation of the movement of discontinuous matter.

In Picasso's gray cubism, the reintegrative parceling of reality is but an example of the ferocious determination of this reality to preserve a figurative aspect in the very discontinuity of matter. The visceral wrenches of the gifted Boccioni are the foreshadowing of the supersonic dynamism and the glorious Apollos of the discontinuity of matter. Duchamp's "King and Queen" we may pass through rapidly because of the discontinuity of matter. Dali's watches are soft because they are the masochistic product of the discontinuity of matter. Mathieu's signs are the royal decrees of the discontinuity of matter.

The dionysiac swarming is there, but all this heroic heterogeneity will remain aesthetically worthless so long as the artistic and classical form of an Apollonian cosmogony has not been found.

If the vitally heterogeneous and anti-academic forces of modern art are not to perish in the anecdotic absurdity of sheer experimental and narcissistic dilettantism, three essential things are needed:

 1. Talent, and preferably genius.[2]

[2] *Since the French Revolution a vicious cretinizing tendency has developed which consists in considering that geniuses (aside from their work) are in every respect beings more or less like other common mortals. This belief is false. I affirm this for myself who am the outstanding modern genius. (S.D.)*

Dali, what a fanatic!

SIGMUND FREUD

2. Learning again how to paint as well as Velasquez and preferably as Vermeer.[3]

3. The possession of a monarchic and Catholic cosmogony, as absolute as possible and having imperialist tendencies.

Only then, like Nietzscheans in reverse, that is to say aspiring to the sublime, shall we observe with the naked eye, "from nature," the antiprotonic archangel so divinely burst that we shall at last be able to plunge our painter's hands between the *fissioned* chromosomes of his nightingalesque substance and with our aching and blood-swollen fingers touch the discontinuous treasure desired since our own youth. And, believing with Soeringe that we control everything by our potential will to power, I know that we shall then touch our own divinity as painters.[4]

Read, approved and signed:
Salvador DALI.

[3] *In his* Mystical Manifesto *that appeared in 1952, Dali was already telling painters: "Painters, paint meticulously with as much reality as a color photograph, let your hand behave like a stroboscope, and then I promise you that from that moment your paintings will have a chance of becoming immortal!" (Editor's note).*

[4] *It may perhaps have been noticed that Dali the writer is not sparing in his admiration for Dali the painter, but this is because he is convinced of the "monarchic" superiority of the painter in general. Three years ago the Iberic anarchist Federation published a manifesto to announce its support of the Spanish monarchy—for, it was specified, painters are monarchs. Herein Dali recognizes one of his most cherished ideas: there is real freedom only under the authority of a monarch. In his childhood he was very fond of wearing a regal disguise, but it is not to this title that he aspires for himself, it is to the one conferred upon him by his given name, Salvador, the savior of painting. In his* Diary of a Genius, *as yet unpublished, he observes, among other things: "Before going to sleep, instead of rubbing my hands (this abominable gesture would be typically anti-Dalinian) I kiss them with a very pure joy, telling myself all the while that the universe is a slight thing compared to the amplitude of a brow painted by Raphael." (Editor's note).*

"I consider Picasso a very great painter. I have fifteen of his canvases in my collection, but never will he paint a picture to equal Dalí's Cena, *for the very simple reason that he is not capable of doing so."*
CHESTER DALE, President of the National Gallery in Washington.

APPENDICES

APPENDIX

DALI'S LUCIDITY WHEN HE SPEAKS
of painting is enough to discourage critics who never approach
the question otherwise than from the outside. In reply to a
survey on the emancipation of painting, Dali, as early as 1934,
stated:

"If I am to express myself briefly on the questions of the
'model,' of the 'spontaneity' and of the element of 'chance'
in the painted work, I shall say that in my opinion—and to
attempt to make these few words as substantial as possible—
the 'model' should be for the painter only a succulent and gelat-
inous 'gratinéd pig's foot' in which, as everyone knows, the soft
and superfine meat merely envelops the true and authentic
peeled bone of objectivity with its 'deliria of nutritive sweet-
ness.' But the best gratinéd and the most savory of all pig's feet
which, if one makes the slightest appeal to memory, is that of
'realism,' happens to have been scented centuries ago by the fine

Painters, do not fear perfection. You will never achieve it! If you are mediocre, and you do your utmost to paint very, very badly, it will still be evident that you are mediocre.

noses of the Dutch painters and finally eaten by Vermeer of
Delft, who left only the cold bone, so that the great Meissonnier
in licking it could discover its last delicate succulence. If in our
day there is no longer any 'model' there is every reason to believe
that it is because the painter ate it, and this is too generally and
too popularly admitted to make it necessary for me to insist on
the inevitable nostalgia of every painter before every model.
How could the pig's foot in question still exist today, when we
know that the surrealists, going beyond the cannibalism of meat,
have passed on to that of bones, finally reaching the point of
devouring objects and object-beings? From all of which you can
gather that the model can exist for me only as an intestinal
metaphor. Not only the model, but even objectivity itself has
been eaten. I can therefore paint only according to certain
systems of digestive delirium.

"As concerns spontaneity, I shall say that it too is a pig's
foot, but a pig's foot in reverse, that is to say a crayfish which,
as everyone knows, unlike the pig's foot, presents an external
skeleton, while the superfine and delicate meat, that is to say
the delirium, occupies the interior, which means—to speak in a
single spurt and without euphemism—that, for spontaneity, the
carapace of objectivity offers a resistance to the soft delirium of
the meat; that, in order to reach the latter, one often loses time
and that in addition one reaches it only to discover that the meat
which one finds has no bone. All these considerations lead me
to be generally suspicious of 'spontaneity' in its pure state, in
which I always recognize the conventional and stereotyped taste
of the invariable restaurant crayfish, and personally to prefer,
rather than spontaneity, "systematization" which, like paranoiac
delirium, can occur and in fact does occur 'spontaneously'—the

'spontaneity' in question having ceased to lay claim to an *undiscoverable objectivity,* especially as it has been previously destroyed, as we have seen in the case of the crayfish, but on the contrary implying that supplementary succulence, the most delicate of all, which resides in the taste and even in the contact of the meat that can still be found and that is found within the bones, when after the bone has been gnawed, the moment of attacking it appears. It is precisely at the algid moment when one reaches the very marrow of the imagination that one has the right to assume that one dominates (as in fact one does dominate) the situation.

"If the 'model' is a gratinéd pig's foot and spontaneity a crayfish, chance could well be merely a serious and important grilled lamb-chop, bubbling with savor and biological ulterior motives. I say this advisedly, because chance represents and constitutes exactly that middle point of succulence between the 'model' and 'spontaneity,' that is to say between the gratinéd pig's foot and the crayfish *à l'armoricaine.* It will in fact be observed that if in the pig's foot the bones are inside the meat and in the crayfish the meat within the skeleton, in the case of the lamb-chop the bones are half inside, half outside, that is to say coexistent, and that the bone and the meat, objectivity and delirium, showing visibly at the same time, do nothing but set forth this truth that I shall never weary of repeating, namely that chance is nothing other than the result of a systematic irrational (paranoiac) activity; which, to come back to our edible obsessions and to our vocabulary borrowed from nutrition, can be summarized in the idea that chance, as it manifests itself in the artistic phenomenon, is merely the expression of the conflict, terribly exciting for famine, which results from our

ELUARD: *So much confusion to remain pure!*

RENÉ CREVEL: *With Bonapartist Trotskyism, he will* renecrevel.*

* *Untranslatable pun on René Crevel's name:* crever *means to croak— He will croak, but in his own personal style. (Translator's note).*

being exposed simultaneously to the bone and the meat, to
specify once again: to objectivity and to delirium, further aggra-
vated by that ardor of the grilled meat burning one's teeth
(every grilled lamb-chop worthy of the name having to be eaten
so hot that it burns one's teeth, but this is another matter)
and when I say 'burning one's teeth' I mean 'burning one's
imagination.' "

BRETON: *So much intelligence for such a tiny downfall!*

ARAGON: *So much climbing to reach such a negligible height!*

APPENDIX II

Around the Birth of a Film

I N 1954 AT THE LOUVRE MUSEUM, Salvador Dali executed a copy of *The Lacemaker* by Vermeer of Delft, a painting whose aggressive power had obsessed him since his childhood. On the canvas Dali painted rhinoceros horns which he was to continue the following spring, but this time at the Zoo in Vincennes before a living rhinoceros. Having returned to Spain, he finished this rhinocerontic and corpuscular copy during the summer of 1955 and in December of the same year delivered a lecture at the Sorbonne in Paris, to explain the affinities, morphological on the one hand and on the other

cosmogonic,[1] discovered by him between the *Lacemaker*, the rhinoceros, the sunflower and the cauliflower.

At the time of the visit to the Louvre Museum, Robert Descharnes undertook the making of a motion-picture film, "The Prodigious Story of the *Lacemaker* and the Rhinoceros," and since then has been making a film record of all Salvador Dali's delirious and systematic investigations and actions.

In this cinematographic "adventure," while Salvador Dali's evolution as a painter is described by means of a certain number of shots of his most important canvases from the surrealist period to the present, the picture does not deal so much with his painting as such, but rather with Dali's evolution, from surrealism to his present paintings (and thereby to his attitude toward contemporary painting).

Thanks to Dali's collaboration, to his genius for correspondences and to the extraordinary systematization of his delirium, "The Prodigious Story of the *Lacemaker* and the Rhinoceros" will be the first film dealing with critical-paranoiac activity;[2] Robert Descharnes attempts to show its development in Dali's life and to explain the application of this method both to his painting and to parallel investigations, like those that lead from Vermeer's *Lacemaker* to gooseflesh[3] via the rhinoceros and the cauliflower.

In order to have the shots that are to show this genius for

[1] *By cosmogonic should be understood "pertaining to the cosmogony (or mythology) peculiar to Dali." (Editor's note).*

[2] *Spontaneous method of irrational knowledge based on the critical interpretative association of delirious phenomena. (Editor's note).*

[3] *For Dali it is primarily the corpuscular divisionist aspect that is the link between Vermeer and this microphysical gooseflesh. (Editor's note).*

correspondences and double images[4] keep their full visual effectiveness, the usual camera tricks and devices have been systematically ruled out.

[4] *"It is by a frankly paranoiac process that it is possible to obtain a double image, that is to say the presentation of an object which, without the slightest figurative or anatomical modification, is at the same time the representation of another, absolutely different object, likewise free of any kind of deformation or abnormality that might conceal some arrangement."* (René Crevel: Dali or Antiobsurantism).

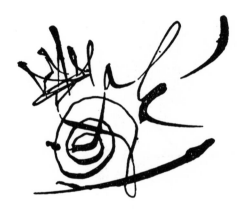

A CATALOG OF SELECTED
DOVER BOOKS
IN ALL FIELDS OF INTEREST

A CATALOG OF SELECTED DOVER
BOOKS IN ALL FIELDS OF INTEREST

CONCERNING THE SPIRITUAL IN ART, Wassily Kandinsky. Pioneering work by father of abstract art. Thoughts on color theory, nature of art. Analysis of earlier masters. 12 illustrations. 80pp. of text. 5⅜ x 8½. 23411-8

ANIMALS: 1,419 Copyright-Free Illustrations of Mammals, Birds, Fish, Insects, etc., Jim Harter (ed.). Clear wood engravings present, in extremely lifelike poses, over 1,000 species of animals. One of the most extensive pictorial sourcebooks of its kind. Captions. Index. 284pp. 9 x 12. 23766-4

CELTIC ART: The Methods of Construction, George Bain. Simple geometric techniques for making Celtic interlacements, spirals, Kells-type initials, animals, humans, etc. Over 500 illustrations. 160pp. 9 x 12. (Available in U.S. only.) 22923-8

AN ATLAS OF ANATOMY FOR ARTISTS, Fritz Schider. Most thorough reference work on art anatomy in the world. Hundreds of illustrations, including selections from works by Vesalius, Leonardo, Goya, Ingres, Michelangelo, others. 593 illustrations. 192pp. 7⅛ x 10¼. 20241-0

CELTIC HAND STROKE-BY-STROKE (Irish Half-Uncial from "The Book of Kells"): An Arthur Baker Calligraphy Manual, Arthur Baker. Complete guide to creating each letter of the alphabet in distinctive Celtic manner. Covers hand position, strokes, pens, inks, paper, more. Illustrated. 48pp. 8¼ x 11. 24336-2

EASY ORIGAMI, John Montroll. Charming collection of 32 projects (hat, cup, pelican, piano, swan, many more) specially designed for the novice origami hobbyist. Clearly illustrated easy-to-follow instructions insure that even beginning papercrafters will achieve successful results. 48pp. 8¼ x 11. 27298-2

THE COMPLETE BOOK OF BIRDHOUSE CONSTRUCTION FOR WOODWORKERS, Scott D. Campbell. Detailed instructions, illustrations, tables. Also data on bird habitat and instinct patterns. Bibliography. 3 tables. 63 illustrations in 15 figures. 48pp. 5¼ x 8½. 24407-5

BLOOMINGDALE'S ILLUSTRATED 1886 CATALOG: Fashions, Dry Goods and Housewares, Bloomingdale Brothers. Famed merchants' extremely rare catalog depicting about 1,700 products: clothing, housewares, firearms, dry goods, jewelry, more. Invaluable for dating, identifying vintage items. Also, copyright-free graphics for artists, designers. Co-published with Henry Ford Museum & Greenfield Village. 160pp. 8¼ x 11. 25780-0

HISTORIC COSTUME IN PICTURES, Braun & Schneider. Over 1,450 costumed figures in clearly detailed engravings–from dawn of civilization to end of 19th century. Captions. Many folk costumes. 256pp. 8⅜ x 11¾. 23150-X

STICKLEY CRAFTSMAN FURNITURE CATALOGS, Gustav Stickley and L. & J. G. Stickley. Beautiful, functional furniture in two authentic catalogs from 1910. 594 illustrations, including 277 photos, show settles, rockers, armchairs, reclining chairs, bookcases, desks, tables. 183pp. 6½ x 9¼. 23838-5

AMERICAN LOCOMOTIVES IN HISTORIC PHOTOGRAPHS: 1858 to 1949, Ron Ziel (ed.). A rare collection of 126 meticulously detailed official photographs, called "builder portraits," of American locomotives that majestically chronicle the rise of steam locomotive power in America. Introduction. Detailed captions. xi+ 129pp. 9 x 12. 27393-8

AMERICA'S LIGHTHOUSES: An Illustrated History, Francis Ross Holland, Jr. Delightfully written, profusely illustrated fact-filled survey of over 200 American lighthouses since 1716. History, anecdotes, technological advances, more. 240pp. 8 x 10¾. 25576-X

TOWARDS A NEW ARCHITECTURE, Le Corbusier. Pioneering manifesto by founder of "International School." Technical and aesthetic theories, views of industry, economics, relation of form to function, "mass-production split" and much more. Profusely illustrated. 320pp. 6⅛ x 9¼. (Available in U.S. only.) 25023-7

HOW THE OTHER HALF LIVES, Jacob Riis. Famous journalistic record, exposing poverty and degradation of New York slums around 1900, by major social reformer. 100 striking and influential photographs. 233pp. 10 x 7⅞. 22012-5

FRUIT KEY AND TWIG KEY TO TREES AND SHRUBS, William M. Harlow. One of the handiest and most widely used identification aids. Fruit key covers 120 deciduous and evergreen species; twig key 160 deciduous species. Easily used. Over 300 photographs. 126pp. 5⅜ x 8½. 20511-8

COMMON BIRD SONGS, Dr. Donald J. Borror. Songs of 60 most common U.S. birds: robins, sparrows, cardinals, bluejays, finches, more—arranged in order of increasing complexity. Up to 9 variations of songs of each species.
Cassette and manual 99911-4

ORCHIDS AS HOUSE PLANTS, Rebecca Tyson Northen. Grow cattleyas and many other kinds of orchids—in a window, in a case, or under artificial light. 63 illustrations. 148pp. 5⅜ x 8½. 23261-1

MONSTER MAZES, Dave Phillips. Masterful mazes at four levels of difficulty. Avoid deadly perils and evil creatures to find magical treasures. Solutions for all 32 exciting illustrated puzzles. 48pp. 8¼ x 11. 26005-4

MOZART'S DON GIOVANNI (DOVER OPERA LIBRETTO SERIES), Wolfgang Amadeus Mozart. Introduced and translated by Ellen H. Bleiler. Standard Italian libretto, with complete English translation. Convenient and thoroughly portable—an ideal companion for reading along with a recording or the performance itself. Introduction. List of characters. Plot summary. 121pp. 5¼ x 8½. 24944-1

TECHNICAL MANUAL AND DICTIONARY OF CLASSICAL BALLET, Gail Grant. Defines, explains, comments on steps, movements, poses and concepts. 15-page pictorial section. Basic book for student, viewer. 127pp. 5⅜ x 8½. 21843-0

THE CLARINET AND CLARINET PLAYING, David Pino. Lively, comprehensive work features suggestions about technique, musicianship, and musical interpretation, as well as guidelines for teaching, making your own reeds, and preparing for public performance. Includes an intriguing look at clarinet history. "A godsend," The Clarinet, Journal of the International Clarinet Society. Appendixes. 7 illus. 320pp. 5⅜ x 8½. 40270-3

HOLLYWOOD GLAMOR PORTRAITS, John Kobal (ed.). 145 photos from 1926-49. Harlow, Gable, Bogart, Bacall; 94 stars in all. Full background on photographers, technical aspects. 160pp. 8⅜ x 11¼. 23352-9

THE ANNOTATED CASEY AT THE BAT: A Collection of Ballads about the Mighty Casey/Third, Revised Edition, Martin Gardner (ed.). Amusing sequels and parodies of one of America's best-loved poems: Casey's Revenge, Why Casey Whiffed, Casey's Sister at the Bat, others. 256pp. 5⅜ x 8½. 28598-7

THE RAVEN AND OTHER FAVORITE POEMS, Edgar Allan Poe. Over 40 of the author's most memorable poems: "The Bells," "Ulalume," "Israfel," "To Helen," "The Conqueror Worm," "Eldorado," "Annabel Lee," many more. Alphabetic lists of titles and first lines. 64pp. 5⅛₆ x 8¼. 26685-0

PERSONAL MEMOIRS OF U. S. GRANT, Ulysses Simpson Grant. Intelligent, deeply moving firsthand account of Civil War campaigns, considered by many the finest military memoirs ever written. Includes letters, historic photographs, maps and more. 528pp. 6⅛ x 9¼. 28587-1

ANCIENT EGYPTIAN MATERIALS AND INDUSTRIES, A. Lucas and J. Harris. Fascinating, comprehensive, thoroughly documented text describes this ancient civilization's vast resources and the processes that incorporated them in daily life, including the use of animal products, building materials, cosmetics, perfumes and incense, fibers, glazed ware, glass and its manufacture, materials used in the mummification process, and much more. 544pp. 6⅛ x 9¼. (Available in U.S. only.) 40446-3

RUSSIAN STORIES/RUSSKIE RASSKAZY: A Dual-Language Book, edited by Gleb Struve. Twelve tales by such masters as Chekhov, Tolstoy, Dostoevsky, Pushkin, others. Excellent word-for-word English translations on facing pages, plus teaching and study aids, Russian/English vocabulary, biographical/critical introductions, more. 416pp. 5⅜ x 8½. 26244-8

PHILADELPHIA THEN AND NOW: 60 Sites Photographed in the Past and Present, Kenneth Finkel and Susan Oyama. Rare photographs of City Hall, Logan Square, Independence Hall, Betsy Ross House, other landmarks juxtaposed with contemporary views. Captures changing face of historic city. Introduction. Captions. 128pp. 8¼ x 11. 25790-8

AIA ARCHITECTURAL GUIDE TO NASSAU AND SUFFOLK COUNTIES, LONG ISLAND, The American Institute of Architects, Long Island Chapter, and the Society for the Preservation of Long Island Antiquities. Comprehensive, well-researched and generously illustrated volume brings to life over three centuries of Long Island's great architectural heritage. More than 240 photographs with authoritative, extensively detailed captions. 176pp. 8¼ x 11. 26946-9

NORTH AMERICAN INDIAN LIFE: Customs and Traditions of 23 Tribes, Elsie Clews Parsons (ed.). 27 fictionalized essays by noted anthropologists examine religion, customs, government, additional facets of life among the Winnebago, Crow, Zuni, Eskimo, other tribes. 480pp. 6⅛ x 9¼. 27377-6

FRANK LLOYD WRIGHT'S DANA HOUSE, Donald Hoffmann. Pictorial essay of residential masterpiece with over 160 interior and exterior photos, plans, elevations, sketches and studies. 128pp. 9¼ x 10¾.
29120-0

THE MALE AND FEMALE FIGURE IN MOTION: 60 Classic Photographic Sequences, Eadweard Muybridge. 60 true-action photographs of men and women walking, running, climbing, bending, turning, etc., reproduced from rare 19th-century masterpiece. vi + 121pp. 9 x 12.
24745-7

1001 QUESTIONS ANSWERED ABOUT THE SEASHORE, N. J. Berrill and Jacquelyn Berrill. Queries answered about dolphins, sea snails, sponges, starfish, fishes, shore birds, many others. Covers appearance, breeding, growth, feeding, much more. 305pp. 5¼ x 8¼.
23366-9

ATTRACTING BIRDS TO YOUR YARD, William J. Weber. Easy-to-follow guide offers advice on how to attract the greatest diversity of birds: birdhouses, feeders, water and waterers, much more. 96pp. 5³⁄₁₆ x 8¼.
28927-3

MEDICINAL AND OTHER USES OF NORTH AMERICAN PLANTS: A Historical Survey with Special Reference to the Eastern Indian Tribes, Charlotte Erichsen-Brown. Chronological historical citations document 500 years of usage of plants, trees, shrubs native to eastern Canada, northeastern U.S. Also complete identifying information. 343 illustrations. 544pp. 6½ x 9¼.
25951-X

STORYBOOK MAZES, Dave Phillips. 23 stories and mazes on two-page spreads: Wizard of Oz, Treasure Island, Robin Hood, etc. Solutions. 64pp. 8¼ x 11.
23628-5

AMERICAN NEGRO SONGS: 230 Folk Songs and Spirituals, Religious and Secular, John W. Work. This authoritative study traces the African influences of songs sung and played by black Americans at work, in church, and as entertainment. The author discusses the lyric significance of such songs as "Swing Low, Sweet Chariot," "John Henry," and others and offers the words and music for 230 songs. Bibliography. Index of Song Titles. 272pp. 6½ x 9¼.
40271-1

MOVIE-STAR PORTRAITS OF THE FORTIES, John Kobal (ed.). 163 glamor, studio photos of 106 stars of the 1940s: Rita Hayworth, Ava Gardner, Marlon Brando, Clark Gable, many more. 176pp. 8⅜ x 11¼.
23546-7

BENCHLEY LOST AND FOUND, Robert Benchley. Finest humor from early 30s, about pet peeves, child psychologists, post office and others. Mostly unavailable elsewhere. 73 illustrations by Peter Arno and others. 183pp. 5⅜ x 8½.
22410-4

YEKL and THE IMPORTED BRIDEGROOM AND OTHER STORIES OF YIDDISH NEW YORK, Abraham Cahan. Film Hester Street based on *Yekl* (1896). Novel, other stories among first about Jewish immigrants on N.Y.'s East Side. 240pp. 5⅜ x 8½.
22427-9

SELECTED POEMS, Walt Whitman. Generous sampling from *Leaves of Grass*. Twenty-four poems include "I Hear America Singing," "Song of the Open Road," "I Sing the Body Electric," "When Lilacs Last in the Dooryard Bloom'd," "O Captain! My Captain!"—all reprinted from an authoritative edition. Lists of titles and first lines. 128pp. 5³⁄₁₆ x 8¼.
26878-0

THE BEST TALES OF HOFFMANN, E. T. A. Hoffmann. 10 of Hoffmann's most important stories: "Nutcracker and the King of Mice," "The Golden Flowerpot," etc. 458pp. 5⅜ x 8½. 21793-0

FROM FETISH TO GOD IN ANCIENT EGYPT, E. A. Wallis Budge. Rich detailed survey of Egyptian conception of "God" and gods, magic, cult of animals, Osiris, more. Also, superb English translations of hymns and legends. 240 illustrations. 545pp. 5⅜ x 8½. 25803-3

FRENCH STORIES/CONTES FRANÇAIS: A Dual-Language Book, Wallace Fowlie. Ten stories by French masters, Voltaire to Camus: "Micromegas" by Voltaire; "The Atheist's Mass" by Balzac; "Minuet" by de Maupassant; "The Guest" by Camus, six more. Excellent English translations on facing pages. Also French-English vocabulary list, exercises, more. 352pp. 5⅜ x 8½. 26443-2

CHICAGO AT THE TURN OF THE CENTURY IN PHOTOGRAPHS: 122 Historic Views from the Collections of the Chicago Historical Society, Larry A. Viskochil. Rare large-format prints offer detailed views of City Hall, State Street, the Loop, Hull House, Union Station, many other landmarks, circa 1904-1913. Introduction. Captions. Maps. 144pp. 9⅜ x 12¼. 24656-6

OLD BROOKLYN IN EARLY PHOTOGRAPHS, 1865-1929, William Lee Younger. Luna Park, Gravesend race track, construction of Grand Army Plaza, moving of Hotel Brighton, etc. 157 previously unpublished photographs. 165pp. 8⅞ x 11¾. 23587-4

THE MYTHS OF THE NORTH AMERICAN INDIANS, Lewis Spence. Rich anthology of the myths and legends of the Algonquins, Iroquois, Pawnees and Sioux, prefaced by an extensive historical and ethnological commentary. 36 illustrations. 480pp. 5⅜ x 8½. 25967-6

AN ENCYCLOPEDIA OF BATTLES: Accounts of Over 1,560 Battles from 1479 B.C. to the Present, David Eggenberger. Essential details of every major battle in recorded history from the first battle of Megiddo in 1479 B.C. to Grenada in 1984. List of Battle Maps. New Appendix covering the years 1967-1984. Index. 99 illustrations. 544pp. 6½ x 9¼. 24913-1

SAILING ALONE AROUND THE WORLD, Captain Joshua Slocum. First man to sail around the world, alone, in small boat. One of great feats of seamanship told in delightful manner. 67 illustrations. 294pp. 5⅜ x 8½. 20326-3

ANARCHISM AND OTHER ESSAYS, Emma Goldman. Powerful, penetrating, prophetic essays on direct action, role of minorities, prison reform, puritan hypocrisy, violence, etc. 271pp. 5⅜ x 8½. 22484-8

MYTHS OF THE HINDUS AND BUDDHISTS, Ananda K. Coomaraswamy and Sister Nivedita. Great stories of the epics; deeds of Krishna, Shiva, taken from puranas, Vedas, folk tales; etc. 32 illustrations. 400pp. 5⅜ x 8½. 21759-0

THE TRAUMA OF BIRTH, Otto Rank. Rank's controversial thesis that anxiety neurosis is caused by profound psychological trauma which occurs at birth. 256pp. 5⅜ x 8½. 27974-X

A THEOLOGICO-POLITICAL TREATISE, Benedict Spinoza. Also contains unfinished Political Treatise. Great classic on religious liberty, theory of government on common consent. R. Elwes translation. Total of 421pp. 5⅜ x 8½. 20249-6

MY BONDAGE AND MY FREEDOM, Frederick Douglass. Born a slave, Douglass became outspoken force in antislavery movement. The best of Douglass' autobiographies. Graphic description of slave life. 464pp. 5⅜ x 8½. 22457-0

FOLLOWING THE EQUATOR: A Journey Around the World, Mark Twain. Fascinating humorous account of 1897 voyage to Hawaii, Australia, India, New Zealand, etc. Ironic, bemused reports on peoples, customs, climate, flora and fauna, politics, much more. 197 illustrations. 720pp. 5⅜ x 8½. 26113-1

THE PEOPLE CALLED SHAKERS, Edward D. Andrews. Definitive study of Shakers: origins, beliefs, practices, dances, social organization, furniture and crafts, etc. 33 illustrations. 351pp. 5⅜ x 8½. 21081-2

THE MYTHS OF GREECE AND ROME, H. A. Guerber. A classic of mythology, generously illustrated, long prized for its simple, graphic, accurate retelling of the principal myths of Greece and Rome, and for its commentary on their origins and significance. With 64 illustrations by Michelangelo, Raphael, Titian, Rubens, Canova, Bernini and others. 480pp. 5⅜ x 8½. 27584-1

PSYCHOLOGY OF MUSIC, Carl E. Seashore. Classic work discusses music as a medium from psychological viewpoint. Clear treatment of physical acoustics, auditory apparatus, sound perception, development of musical skills, nature of musical feeling, host of other topics. 88 figures. 408pp. 5⅜ x 8½. 21851-1

THE PHILOSOPHY OF HISTORY, Georg W. Hegel. Great classic of Western thought develops concept that history is not chance but rational process, the evolution of freedom. 457pp. 5⅜ x 8½. 20112-0

THE BOOK OF TEA, Kakuzo Okakura. Minor classic of the Orient: entertaining, charming explanation, interpretation of traditional Japanese culture in terms of tea ceremony. 94pp. 5⅜ x 8½. 20070-1

LIFE IN ANCIENT EGYPT, Adolf Erman. Fullest, most thorough, detailed older account with much not in more recent books, domestic life, religion, magic, medicine, commerce, much more. Many illustrations reproduce tomb paintings, carvings, hieroglyphs, etc. 597pp. 5⅜ x 8½. 22632-8

SUNDIALS, Their Theory and Construction, Albert Waugh. Far and away the best, most thorough coverage of ideas, mathematics concerned, types, construction, adjusting anywhere. Simple, nontechnical treatment allows even children to build several of these dials. Over 100 illustrations. 230pp. 5⅜ x 8½. 22947-5

THEORETICAL HYDRODYNAMICS, L. M. Milne-Thomson. Classic exposition of the mathematical theory of fluid motion, applicable to both hydrodynamics and aerodynamics. Over 600 exercises. 768pp. 6⅛ x 9¼. 68970-0

SONGS OF EXPERIENCE: Facsimile Reproduction with 26 Plates in Full Color, William Blake. 26 full-color plates from a rare 1826 edition. Includes "The Tyger," "London," "Holy Thursday," and other poems. Printed text of poems. 48pp. 5¼ x 7. 24636-1

OLD-TIME VIGNETTES IN FULL COLOR, Carol Belanger Grafton (ed.). Over 390 charming, often sentimental illustrations, selected from archives of Victorian graphics—pretty women posing, children playing, food, flowers, kittens and puppies, smiling cherubs, birds and butterflies, much more. All copyright-free. 48pp. 9¼ x 12¼. 27269-9

PERSPECTIVE FOR ARTISTS, Rex Vicat Cole. Depth, perspective of sky and sea, shadows, much more, not usually covered. 391 diagrams, 81 reproductions of drawings and paintings. 279pp. 5⅜ x 8½. 22487-2

DRAWING THE LIVING FIGURE, Joseph Sheppard. Innovative approach to artistic anatomy focuses on specifics of surface anatomy, rather than muscles and bones. Over 170 drawings of live models in front, back and side views, and in widely varying poses. Accompanying diagrams. 177 illustrations. Introduction. Index. 144pp. 8⅜ x11¼. 26723-7

GOTHIC AND OLD ENGLISH ALPHABETS: 100 Complete Fonts, Dan X. Solo. Add power, elegance to posters, signs, other graphics with 100 stunning copyright-free alphabets: Blackstone, Dolbey, Germania, 97 more–including many lower-case, numerals, punctuation marks. 104pp. 8¼ x 11. 24695-7

HOW TO DO BEADWORK, Mary White. Fundamental book on craft from simple projects to five-bead chains and woven works. 106 illustrations. 142pp. 5⅜ x 8. 20697-1

THE BOOK OF WOOD CARVING, Charles Marshall Sayers. Finest book for beginners discusses fundamentals and offers 34 designs. "Absolutely first rate . . . well thought out and well executed."–E. J. Tangerman. 118pp. 7¾ x 10⅝. 23654-4

ILLUSTRATED CATALOG OF CIVIL WAR MILITARY GOODS: Union Army Weapons, Insignia, Uniform Accessories, and Other Equipment, Schuyler, Hartley, and Graham. Rare, profusely illustrated 1846 catalog includes Union Army uniform and dress regulations, arms and ammunition, coats, insignia, flags, swords, rifles, etc. 226 illustrations. 160pp. 9 x 12. 24939-5

WOMEN'S FASHIONS OF THE EARLY 1900s: An Unabridged Republication of "New York Fashions, 1909," National Cloak & Suit Co. Rare catalog of mail-order fashions documents women's and children's clothing styles shortly after the turn of the century. Captions offer full descriptions, prices. Invaluable resource for fashion, costume historians. Approximately 725 illustrations. 128pp. 8⅜ x 11¼. 27276-1

THE 1912 AND 1915 GUSTAV STICKLEY FURNITURE CATALOGS, Gustav Stickley. With over 200 detailed illustrations and descriptions, these two catalogs are essential reading and reference materials and identification guides for Stickley furniture. Captions cite materials, dimensions and prices. 112pp. 6½ x 9¼. 26676-1

EARLY AMERICAN LOCOMOTIVES, John H. White, Jr. Finest locomotive engravings from early 19th century: historical (1804–74), main-line (after 1870), special, foreign, etc. 147 plates. 142pp. 11⅜ x 8¼. 22772-3

THE TALL SHIPS OF TODAY IN PHOTOGRAPHS, Frank O. Braynard. Lavishly illustrated tribute to nearly 100 majestic contemporary sailing vessels: Amerigo Vespucci, Clearwater, Constitution, Eagle, Mayflower, Sea Cloud, Victory, many more. Authoritative captions provide statistics, background on each ship. 190 black-and-white photographs and illustrations. Introduction. 128pp. 8⅜ x 11¾. 27163-3

LITTLE BOOK OF EARLY AMERICAN CRAFTS AND TRADES, Peter Stockham (ed.). 1807 children's book explains crafts and trades: baker, hatter, cooper, potter, and many others. 23 copperplate illustrations. 140pp. 4⅝ x 6. 23336-7

VICTORIAN FASHIONS AND COSTUMES FROM HARPER'S BAZAR, 1867–1898, Stella Blum (ed.). Day costumes, evening wear, sports clothes, shoes, hats, other accessories in over 1,000 detailed engravings. 320pp. 9⅜ x 12¼. 22990-4

GUSTAV STICKLEY, THE CRAFTSMAN, Mary Ann Smith. Superb study surveys broad scope of Stickley's achievement, especially in architecture. Design philosophy, rise and fall of the Craftsman empire, descriptions and floor plans for many Craftsman houses, more. 86 black-and-white halftones. 31 line illustrations. Introduction 208pp. 6½ x 9¼. 27210-9

THE LONG ISLAND RAIL ROAD IN EARLY PHOTOGRAPHS, Ron Ziel. Over 220 rare photos, informative text document origin (1844) and development of rail service on Long Island. Vintage views of early trains, locomotives, stations, passengers, crews, much more. Captions. 8⅞ x 11¾. 26301-0

VOYAGE OF THE LIBERDADE, Joshua Slocum. Great 19th-century mariner's thrilling, first-hand account of the wreck of his ship off South America, the 35-foot boat he built from the wreckage, and its remarkable voyage home. 128pp. 5⅜ x 8½. 40022-0

TEN BOOKS ON ARCHITECTURE, Vitruvius. The most important book ever written on architecture. Early Roman aesthetics, technology, classical orders, site selection, all other aspects. Morgan translation. 331pp. 5⅜ x 8½. 20645-9

THE HUMAN FIGURE IN MOTION, Eadweard Muybridge. More than 4,500 stopped-action photos, in action series, showing undraped men, women, children jumping, lying down, throwing, sitting, wrestling, carrying, etc. 390pp. 7⅞ x 10⅝. 20204-6 Clothbd.

TREES OF THE EASTERN AND CENTRAL UNITED STATES AND CANADA, William M. Harlow. Best one-volume guide to 140 trees. Full descriptions, woodlore, range, etc. Over 600 illustrations. Handy size. 288pp. 4½ x 6⅜. 20395-6

SONGS OF WESTERN BIRDS, Dr. Donald J. Borror. Complete song and call repertoire of 60 western species, including flycatchers, juncoes, cactus wrens, many more—includes fully illustrated booklet. Cassette and manual 99913-0

GROWING AND USING HERBS AND SPICES, Milo Miloradovich. Versatile handbook provides all the information needed for cultivation and use of all the herbs and spices available in North America. 4 illustrations. Index. Glossary. 236pp. 5⅜ x 8½. 25058-X

BIG BOOK OF MAZES AND LABYRINTHS, Walter Shepherd. 50 mazes and labyrinths in all—classical, solid, ripple, and more—in one great volume. Perfect inexpensive puzzler for clever youngsters. Full solutions. 112pp. 8⅛ x 11. 22951-3

PIANO TUNING, J. Cree Fischer. Clearest, best book for beginner, amateur. Simple repairs, raising dropped notes, tuning by easy method of flattened fifths. No previous skills needed. 4 illustrations. 201pp. 5⅜ x 8½. 23267-0

HINTS TO SINGERS, Lillian Nordica. Selecting the right teacher, developing confidence, overcoming stage fright, and many other important skills receive thoughtful discussion in this indispensible guide, written by a world-famous diva of four decades' experience. 96pp. 5⅜ x 8½. 40094-8

THE COMPLETE NONSENSE OF EDWARD LEAR, Edward Lear. All nonsense limericks, zany alphabets, Owl and Pussycat, songs, nonsense botany, etc., illustrated by Lear. Total of 320pp. 5⅜ x 8½. (Available in U.S. only.) 20167-8

VICTORIAN PARLOUR POETRY: An Annotated Anthology, Michael R. Turner. 117 gems by Longfellow, Tennyson, Browning, many lesser-known poets. "The Village Blacksmith," "Curfew Must Not Ring Tonight," "Only a Baby Small," dozens more, often difficult to find elsewhere. Index of poets, titles, first lines. xxiii + 325pp. 5⅜ x 8¼. 27044-0

DUBLINERS, James Joyce. Fifteen stories offer vivid, tightly focused observations of the lives of Dublin's poorer classes. At least one, "The Dead," is considered a masterpiece. Reprinted complete and unabridged from standard edition. 160pp. 5³⁄₁₆ x 8¼. 26870-5

GREAT WEIRD TALES: 14 Stories by Lovecraft, Blackwood, Machen and Others, S. T. Joshi (ed.). 14 spellbinding tales, including "The Sin Eater," by Fiona McLeod, "The Eye Above the Mantel," by Frank Belknap Long, as well as renowned works by R. H. Barlow, Lord Dunsany, Arthur Machen, W. C. Morrow and eight other masters of the genre. 256pp. 5⅜ x 8½. (Available in U.S. only.) 40436-6

THE BOOK OF THE SACRED MAGIC OF ABRAMELIN THE MAGE, translated by S. MacGregor Mathers. Medieval manuscript of ceremonial magic. Basic document in Aleister Crowley, Golden Dawn groups. 268pp. 5⅜ x 8½. 23211-5

NEW RUSSIAN-ENGLISH AND ENGLISH-RUSSIAN DICTIONARY, M. A. O'Brien. This is a remarkably handy Russian dictionary, containing a surprising amount of information, including over 70,000 entries. 366pp. 4½ x 6⅛. 20208-9

HISTORIC HOMES OF THE AMERICAN PRESIDENTS, Second, Revised Edition, Irvin Haas. A traveler's guide to American Presidential homes, most open to the public, depicting and describing homes occupied by every American President from George Washington to George Bush. With visiting hours, admission charges, travel routes. 175 photographs. Index. 160pp. 8¼ x 11. 26751-2

NEW YORK IN THE FORTIES, Andreas Feininger. 162 brilliant photographs by the well-known photographer, formerly with *Life* magazine. Commuters, shoppers, Times Square at night, much else from city at its peak. Captions by John von Hartz. 181pp. 9¼ x 10¾. 23585-8

INDIAN SIGN LANGUAGE, William Tomkins. Over 525 signs developed by Sioux and other tribes. Written instructions and diagrams. Also 290 pictographs. 111pp. 6⅛ x 9¼. 22029-X

ANATOMY: A Complete Guide for Artists, Joseph Sheppard. A master of figure drawing shows artists how to render human anatomy convincingly. Over 460 illustrations. 224pp. 8⅜ x 11¼. 27279-6

MEDIEVAL CALLIGRAPHY: Its History and Technique, Marc Drogin. Spirited history, comprehensive instruction manual covers 13 styles (ca. 4th century through 15th). Excellent photographs; directions for duplicating medieval techniques with modern tools. 224pp. 8⅜ x 11¼. 26142-5

DRIED FLOWERS: How to Prepare Them, Sarah Whitlock and Martha Rankin. Complete instructions on how to use silica gel, meal and borax, perlite aggregate, sand and borax, glycerine and water to create attractive permanent flower arrangements. 12 illustrations. 32pp. 5⅜ x 8½. 21802-3

EASY-TO-MAKE BIRD FEEDERS FOR WOODWORKERS, Scott D. Campbell. Detailed, simple-to-use guide for designing, constructing, caring for and using feeders. Text, illustrations for 12 classic and contemporary designs. 96pp. 5⅜ x 8½. 25847-5

SCOTTISH WONDER TALES FROM MYTH AND LEGEND, Donald A. Mackenzie. 16 lively tales tell of giants rumbling down mountainsides, of a magic wand that turns stone pillars into warriors, of gods and goddesses, evil hags, powerful forces and more. 240pp. 5⅜ x 8½. 29677-6

THE HISTORY OF UNDERCLOTHES, C. Willett Cunnington and Phyllis Cunnington. Fascinating, well-documented survey covering six centuries of English undergarments, enhanced with over 100 illustrations: 12th-century laced-up bodice, footed long drawers (1795), 19th-century bustles, 19th-century corsets for men, Victorian "bust improvers," much more. 272pp. 5⅜ x 8¼. 27124-2

ARTS AND CRAFTS FURNITURE: The Complete Brooks Catalog of 1912, Brooks Manufacturing Co. Photos and detailed descriptions of more than 150 now very collectible furniture designs from the Arts and Crafts movement depict davenports, settees, buffets, desks, tables, chairs, bedsteads, dressers and more, all built of solid, quarter-sawed oak. Invaluable for students and enthusiasts of antiques, Americana and the decorative arts. 80pp. 6½ x 9¼. 27471-3

WILBUR AND ORVILLE: A Biography of the Wright Brothers, Fred Howard. Definitive, crisply written study tells the full story of the brothers' lives and work. A vividly written biography, unparalleled in scope and color, that also captures the spirit of an extraordinary era. 560pp. 6⅛ x 9¼. 40297-5

THE ARTS OF THE SAILOR: Knotting, Splicing and Ropework, Hervey Garrett Smith. Indispensable shipboard reference covers tools, basic knots and useful hitches; handsewing and canvas work, more. Over 100 illustrations. Delightful reading for sea lovers. 256pp. 5⅜ x 8½. 26440-8

FRANK LLOYD WRIGHT'S FALLINGWATER: The House and Its History, Second, Revised Edition, Donald Hoffmann. A total revision—both in text and illustrations—of the standard document on Fallingwater, the boldest, most personal architectural statement of Wright's mature years, updated with valuable new material from the recently opened Frank Lloyd Wright Archives. "Fascinating"—*The New York Times*. 116 illustrations. 128pp. 9¼ x 10¾. 27430-6

PHOTOGRAPHIC SKETCHBOOK OF THE CIVIL WAR, Alexander Gardner. 100 photos taken on field during the Civil War. Famous shots of Manassas Harper's Ferry, Lincoln, Richmond, slave pens, etc. 244pp. 10⅝ x 8¼. 22731-6

FIVE ACRES AND INDEPENDENCE, Maurice G. Kains. Great back-to-the-land classic explains basics of self-sufficient farming. The one book to get. 95 illustrations. 397pp. 5⅜ x 8½. 20974-1

SONGS OF EASTERN BIRDS, Dr. Donald J. Borror. Songs and calls of 60 species most common to eastern U.S.: warblers, woodpeckers, flycatchers, thrushes, larks, many more in high-quality recording. Cassette and manual 99912-2

A MODERN HERBAL, Margaret Grieve. Much the fullest, most exact, most useful compilation of herbal material. Gigantic alphabetical encyclopedia, from aconite to zedoary, gives botanical information, medical properties, folklore, economic uses, much else. Indispensable to serious reader. 161 illustrations. 888pp. 6½ x 9¼. 2-vol. set. (Available in U.S. only.) Vol. I: 22798-7
Vol. II: 22799-5

HIDDEN TREASURE MAZE BOOK, Dave Phillips. Solve 34 challenging mazes accompanied by heroic tales of adventure. Evil dragons, people-eating plants, blood-thirsty giants, many more dangerous adversaries lurk at every twist and turn. 34 mazes, stories, solutions. 48pp. 8¼ x 11. 24566-7

LETTERS OF W. A. MOZART, Wolfgang A. Mozart. Remarkable letters show bawdy wit, humor, imagination, musical insights, contemporary musical world; includes some letters from Leopold Mozart. 276pp. 5⅜ x 8½. 22859-2

BASIC PRINCIPLES OF CLASSICAL BALLET, Agrippina Vaganova. Great Russian theoretician, teacher explains methods for teaching classical ballet. 118 illustrations. 175pp. 5⅜ x 8½. 22036-2

THE JUMPING FROG, Mark Twain. Revenge edition. The original story of The Celebrated Jumping Frog of Calaveras County, a hapless French translation, and Twain's hilarious "retranslation" from the French. 12 illustrations. 66pp. 5⅜ x 8½. 22686-7

BEST REMEMBERED POEMS, Martin Gardner (ed.). The 126 poems in this superb collection of 19th- and 20th-century British and American verse range from Shelley's "To a Skylark" to the impassioned "Renascence" of Edna St. Vincent Millay and to Edward Lear's whimsical "The Owl and the Pussycat." 224pp. 5⅜ x 8½. 27165-X

COMPLETE SONNETS, William Shakespeare. Over 150 exquisite poems deal with love, friendship, the tyranny of time, beauty's evanescence, death and other themes in language of remarkable power, precision and beauty. Glossary of archaic terms. 80pp. 5³⁄₁₆ x 8¼. 26686-9

THE BATTLES THAT CHANGED HISTORY, Fletcher Pratt. Eminent historian profiles 16 crucial conflicts, ancient to modern, that changed the course of civilization. 352pp. 5⅜ x 8½. 41129-X

THE WIT AND HUMOR OF OSCAR WILDE, Alvin Redman (ed.). More than 1,000 ripostes, paradoxes, wisecracks: Work is the curse of the drinking classes; I can resist everything except temptation; etc. 258pp. 5⅜ x 8½. 20602-5

SHAKESPEARE LEXICON AND QUOTATION DICTIONARY, Alexander Schmidt. Full definitions, locations, shades of meaning in every word in plays and poems. More than 50,000 exact quotations. 1,485pp. 6½ x 9¼. 2-vol. set.
Vol. 1: 22726-X
Vol. 2: 22727-8

SELECTED POEMS, Emily Dickinson. Over 100 best-known, best-loved poems by one of America's foremost poets, reprinted from authoritative early editions. No comparable edition at this price. Index of first lines. 64pp. 5³⁄₁₆ x 8¼. 26466-1

THE INSIDIOUS DR. FU-MANCHU, Sax Rohmer. The first of the popular mystery series introduces a pair of English detectives to their archnemesis, the diabolical Dr. Fu-Manchu. Flavorful atmosphere, fast-paced action, and colorful characters enliven this classic of the genre. 208pp. 5³⁄₁₆ x 8¼. 29898-1

THE MALLEUS MALEFICARUM OF KRAMER AND SPRENGER, translated by Montague Summers. Full text of most important witchhunter's "bible," used by both Catholics and Protestants. 278pp. 6⅝ x 10. 22802-9

SPANISH STORIES/CUENTOS ESPAÑOLES: A Dual-Language Book, Angel Flores (ed.). Unique format offers 13 great stories in Spanish by Cervantes, Borges, others. Faithful English translations on facing pages. 352pp. 5⅜ x 8½. 25399-6

GARDEN CITY, LONG ISLAND, IN EARLY PHOTOGRAPHS, 1869–1919, Mildred H. Smith. Handsome treasury of 118 vintage pictures, accompanied by carefully researched captions, document the Garden City Hotel fire (1899), the Vanderbilt Cup Race (1908), the first airmail flight departing from the Nassau Boulevard Aerodrome (1911), and much more. 96pp. 8⅞ x 11¾. 40669-5

OLD QUEENS, N.Y., IN EARLY PHOTOGRAPHS, Vincent F. Seyfried and William Asadorian. Over 160 rare photographs of Maspeth, Jamaica, Jackson Heights, and other areas. Vintage views of DeWitt Clinton mansion, 1939 World's Fair and more. Captions. 192pp. 8⅞ x 11. 26358-4

CAPTURED BY THE INDIANS: 15 Firsthand Accounts, 1750-1870, Frederick Drimmer. Astounding true historical accounts of grisly torture, bloody conflicts, relentless pursuits, miraculous escapes and more, by people who lived to tell the tale. 384pp. 5⅜ x 8½. 24901-8

THE WORLD'S GREAT SPEECHES (Fourth Enlarged Edition), Lewis Copeland, Lawrence W. Lamm, and Stephen J. McKenna. Nearly 300 speeches provide public speakers with a wealth of updated quotes and inspiration—from Pericles' funeral oration and William Jennings Bryan's "Cross of Gold Speech" to Malcolm X's powerful words on the Black Revolution and Earl of Spenser's tribute to his sister, Diana, Princess of Wales. 944pp. 5⅜ x 8½. 40903-1

THE BOOK OF THE SWORD, Sir Richard F. Burton. Great Victorian scholar/adventurer's eloquent, erudite history of the "queen of weapons"—from prehistory to early Roman Empire. Evolution and development of early swords, variations (sabre, broadsword, cutlass, scimitar, etc.), much more. 336pp. 6⅛ x 9¼. 25434-8

AUTOBIOGRAPHY: The Story of My Experiments with Truth, Mohandas K. Gandhi. Boyhood, legal studies, purification, the growth of the Satyagraha (nonviolent protest) movement. Critical, inspiring work of the man responsible for the freedom of India. 480pp. 5⅜ x 8½. (Available in U.S. only.) 24593-4

CELTIC MYTHS AND LEGENDS, T. W. Rolleston. Masterful retelling of Irish and Welsh stories and tales. Cuchulain, King Arthur, Deirdre, the Grail, many more. First paperback edition. 58 full-page illustrations. 512pp. 5⅜ x 8½. 26507-2

THE PRINCIPLES OF PSYCHOLOGY, William James. Famous long course complete, unabridged. Stream of thought, time perception, memory, experimental methods; great work decades ahead of its time. 94 figures. 1,391pp. 5⅜ x 8½. 2-vol. set.
Vol. I: 20381-6 Vol. II: 20382-4

THE WORLD AS WILL AND REPRESENTATION, Arthur Schopenhauer. Definitive English translation of Schopenhauer's life work, correcting more than 1,000 errors, omissions in earlier translations. Translated by E. F. J. Payne. Total of 1,269pp. 5⅜ x 8½. 2-vol. set.
Vol. 1: 21761-2 Vol. 2: 21762-0

MAGIC AND MYSTERY IN TIBET, Madame Alexandra David-Neel. Experiences among lamas, magicians, sages, sorcerers, Bonpa wizards. A true psychic discovery. 32 illustrations. 321pp. 5⅜ x 8½. (Available in U.S. only.) 22682-4

THE EGYPTIAN BOOK OF THE DEAD, E. A. Wallis Budge. Complete reproduction of Ani's papyrus, finest ever found. Full hieroglyphic text, interlinear transliteration, word-for-word translation, smooth translation. 533pp. 6½ x 9¼. 21866-X

MATHEMATICS FOR THE NONMATHEMATICIAN, Morris Kline. Detailed, college-level treatment of mathematics in cultural and historical context, with numerous exercises. Recommended Reading Lists. Tables. Numerous figures. 641pp. 5⅜ x 8½. 24823-2

PROBABILISTIC METHODS IN THE THEORY OF STRUCTURES, Isaac Elishakoff. Well-written introduction covers the elements of the theory of probability from two or more random variables, the reliability of such multivariable structures, the theory of random function, Monte Carlo methods of treating problems incapable of exact solution, and more. Examples. 502pp. 5⅜ x 8½. 40691-1

THE RIME OF THE ANCIENT MARINER, Gustave Doré, S. T. Coleridge. Doré's finest work; 34 plates capture moods, subtleties of poem. Flawless full-size reproductions printed on facing pages with authoritative text of poem. "Beautiful. Simply beautiful."—*Publisher's Weekly.* 77pp. 9¼ x 12. 22305-1

NORTH AMERICAN INDIAN DESIGNS FOR ARTISTS AND CRAFTSPEOPLE, Eva Wilson. Over 360 authentic copyright-free designs adapted from Navajo blankets, Hopi pottery, Sioux buffalo hides, more. Geometrics, symbolic figures, plant and animal motifs, etc. 128pp. 8⅜ x 11. (Not for sale in the United Kingdom.) 25341-4

SCULPTURE: Principles and Practice, Louis Slobodkin. Step-by-step approach to clay, plaster, metals, stone; classical and modern. 253 drawings, photos. 255pp. 8⅛ x 11. 22960-2

THE INFLUENCE OF SEA POWER UPON HISTORY, 1660–1783, A. T. Mahan. Influential classic of naval history and tactics still used as text in war colleges. First paperback edition. 4 maps. 24 battle plans. 640pp. 5⅜ x 8½. 25509-3

THE STORY OF THE TITANIC AS TOLD BY ITS SURVIVORS, Jack Winocour (ed.). What it was really like. Panic, despair, shocking inefficiency, and a little heroism. More thrilling than any fictional account. 26 illustrations. 320pp. 5⅜ x 8½.
20610-6

FAIRY AND FOLK TALES OF THE IRISH PEASANTRY, William Butler Yeats (ed.). Treasury of 64 tales from the twilight world of Celtic myth and legend: "The Soul Cages," "The Kildare Pooka," "King O'Toole and his Goose," many more. Introduction and Notes by W. B. Yeats. 352pp. 5⅜ x 8½.
26941-8

BUDDHIST MAHAYANA TEXTS, E. B. Cowell and others (eds.). Superb, accurate translations of basic documents in Mahayana Buddhism, highly important in history of religions. The Buddha-karita of Asvaghosha, Larger Sukhavativyuha, more. 448pp. 5⅜ x 8½.
25552-2

ONE TWO THREE . . . INFINITY: Facts and Speculations of Science, George Gamow. Great physicist's fascinating, readable overview of contemporary science: number theory, relativity, fourth dimension, entropy, genes, atomic structure, much more. 128 illustrations. Index. 352pp. 5⅜ x 8½.
25664-2

EXPERIMENTATION AND MEASUREMENT, W. J. Youden. Introductory manual explains laws of measurement in simple terms and offers tips for achieving accuracy and minimizing errors. Mathematics of measurement, use of instruments, experimenting with machines. 1994 edition. Foreword. Preface. Introduction. Epilogue. Selected Readings. Glossary. Index. Tables and figures. 128pp. 5⅜ x 8½. 40451-X

DALÍ ON MODERN ART: The Cuckolds of Antiquated Modern Art, Salvador Dalí. Influential painter skewers modern art and its practitioners. Outrageous evaluations of Picasso, Cézanne, Turner, more. 15 renderings of paintings discussed. 44 calligraphic decorations by Dalí. 96pp. 5⅜ x 8½. (Available in U.S. only.) 29220-7

ANTIQUE PLAYING CARDS: A Pictorial History, Henry René D'Allemagne. Over 900 elaborate, decorative images from rare playing cards (14th–20th centuries): Bacchus, death, dancing dogs, hunting scenes, royal coats of arms, players cheating, much more. 96pp. 9¼ x 12¼. 29265-7

MAKING FURNITURE MASTERPIECES: 30 Projects with Measured Drawings, Franklin H. Gottshall. Step-by-step instructions, illustrations for constructing handsome, useful pieces, among them a Sheraton desk, Chippendale chair, Spanish desk, Queen Anne table and a William and Mary dressing mirror. 224pp. 8⅛ x 11¼.
29338-6

THE FOSSIL BOOK: A Record of Prehistoric Life, Patricia V. Rich et al. Profusely illustrated definitive guide covers everything from single-celled organisms and dinosaurs to birds and mammals and the interplay between climate and man. Over 1,500 illustrations. 760pp. 7½ x 10⅛. 29371-8

Paperbound unless otherwise indicated. Available at your book dealer, online at **www.doverpublications.com**, or by writing to Dept. GI, Dover Publications, Inc., 31 East 2nd Street, Mineola, NY 11501. For current price information or for free catalogues (please indicate field of interest), write to Dover Publications or log on to **www.doverpublications.com** and see every Dover book in print. Dover publishes more than 500 books each year on science, elementary and advanced mathematics, biology, music, art, literary history, social sciences, and other areas.